BESTIES

BESTIES

Leah Reena Goren

CLARKSON POTTER/PUBLISHERS

NEW YORK

Library of Congress Cataloging-in-Publication Data
Names: Goren, Leah Reena, author.
Title: Besties / Leah Reena Goren.
Description: First edition. | New York : Clarkson Potter/Publishers, 2015. |
Identifiers: LCCN 2015045563 (print) | LCCN 2015041807 (ebook) | ISBN
 9780553496369 (ebook) | ISBN 9780553496352 (hardcover)
Subjects: LCSH: Friendship—Humor. | Female friendship—Humor.
Classification: LCC PN6231.F748 (print) | LCC PN6231.F748 G68 2016 (ebook) |
 DDC 818/.602—dc23
LC record available at http://lccn.loc.gov/2015045563

ISBN 978-0-553-49635-2
eBook ISBN 978-0-553-49636-9

Printed in China

Conceived and compiled by Leah Reena Goren
Written in collaboration with Hallie Bateman
Illustrations by Leah Reena Goren

10 9 8 7 6 5 4 3 2

First Edition

For my best friends,
Taylor (a girl) and Moses (a cat)

I cringe when people say we're "attached at the hip." It reminds me of all those medical mystery shows that you loved and I hated.

I don't really like "buddies" either, because I can't stop picturing us as bandanna-wearing dog friends.

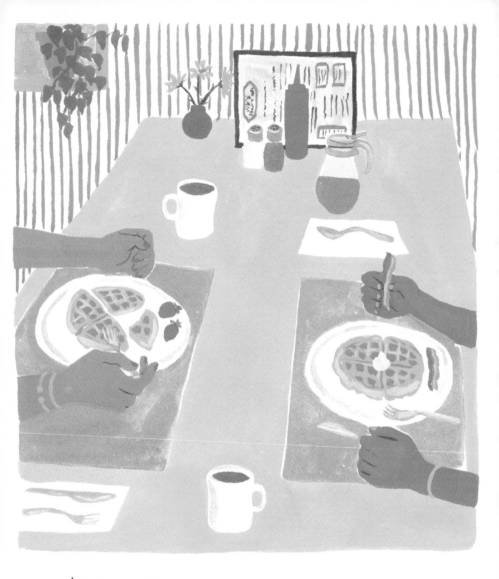

"Galentine" is great — but only once a year, on February 13, when we celebrate Galentine's Day at Jeb's House of Waffles.

I like "BFFL"— best friends for life. With the shameless cliché and the innocence of the for life part, it's perfect for our totally not ironic gold necklaces.

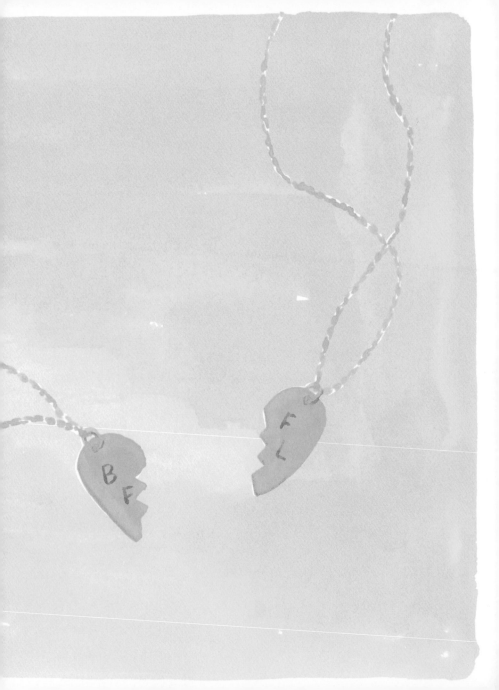

But day after day, "besties" is just right. It's perfectly sweet, to the point, and with just enough nostalgia to make us smile. We'll always be besties.

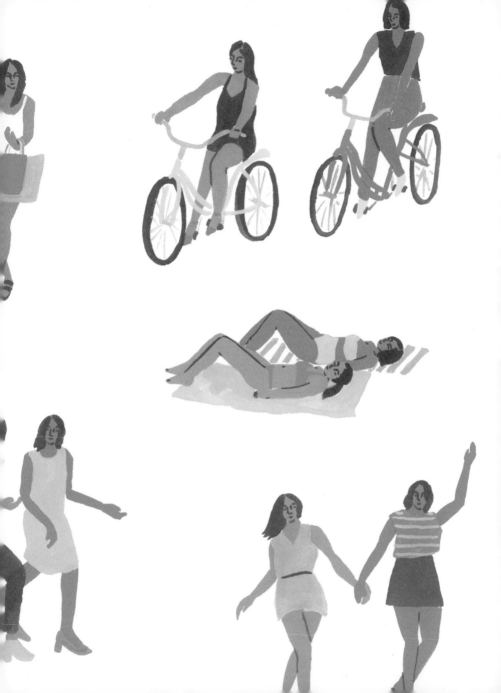

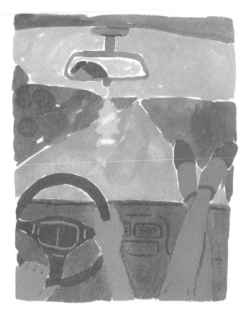

Long drives

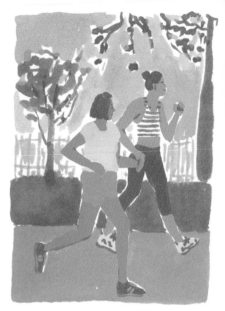

Exercise

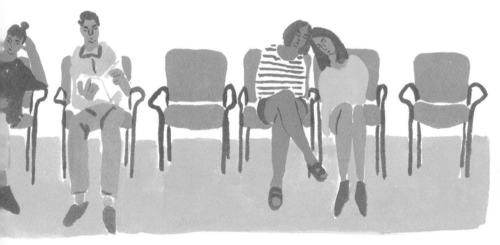

Waiting rooms

My part-time job

This pretentious art opening

And this awful party

EVERYTHING IS JUST SOMEHOW BETTER WHEN YOU'RE THERE.

WE'RE KIND OF LIKE SISTERS WITH THE HUGE ADDED BONUS OF DOUBLE THE FAMILY.

You always had cooler snacks...

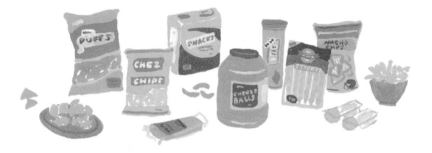

... because your mom shopped at that megawarehouse store, where everything comes in a case of 50.

My cereal

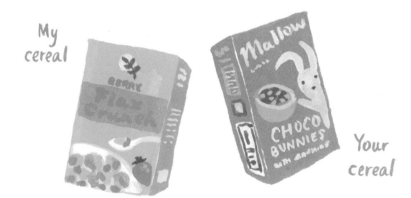

Your cereal

Mine was a small box of something plain and healthy; yours was a case of something exciting.

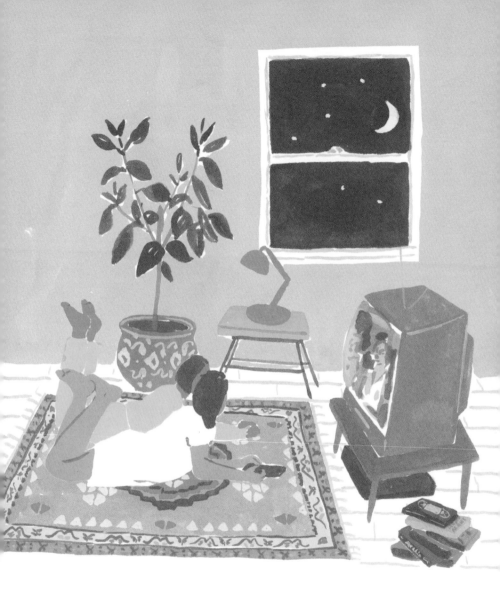

I had a pool and a trampoline. But at your house, we were allowed to watch TV until midnight on weekends.

WE'RE ALWAYS LEARNING FROM EACH OTHER.

"cafecito con leche"

"tantas curvas"

"corazonita"

A few words in Spanish

Step 1

Step 2

Step 3

How to get that perfect cat-eye swoop

How to fold clothes the <u>right</u> way

What to order for breakfast at the bodega

Not to fear falling

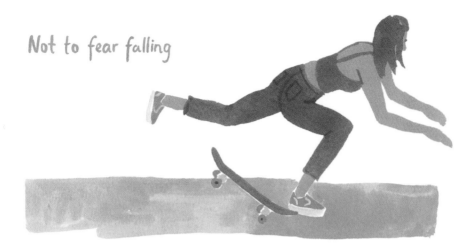

What is <u>not</u> a bedbug

No No No No (Also no)

And always, always to wear sunscreen

SECRET LANGUAGES

I'd love to see the NSA try to crack our texts.

LAUGHTER

gwehhehhahhhhh

When I don't expect to laugh, so I sound like an animal

mmmehehehhehhehehe

When I know something you don't

HAHHAHHAHAHHA

You cracked a tiny smile in real life

haaaaaaah

When I'm too tired to laugh, so I kind of sigh it out

hahahahahahahahaha...hahahaha...hahahah... haha...ha...ha

When we laugh until we physically can't anymore

LOOKS AND EXPRESSIONS

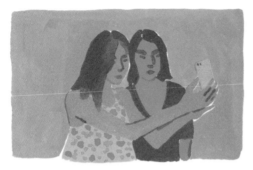

Selfie time

The face you make at yourself in the mirror without even realizing it

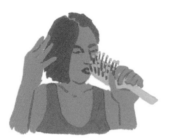

Your backup jazz singer routine

Feigned innocence, like when you're about to ask to borrow my leopard shirt. Again.

I gotchu

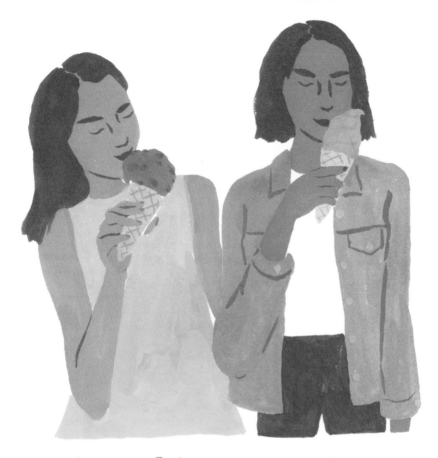

First-bite-of-ice-cream bliss

A wrath of fury is about to be unleashed

Concentrating super hard

Deep frustration

INSIDE JOKES

We won't even try to explain these.

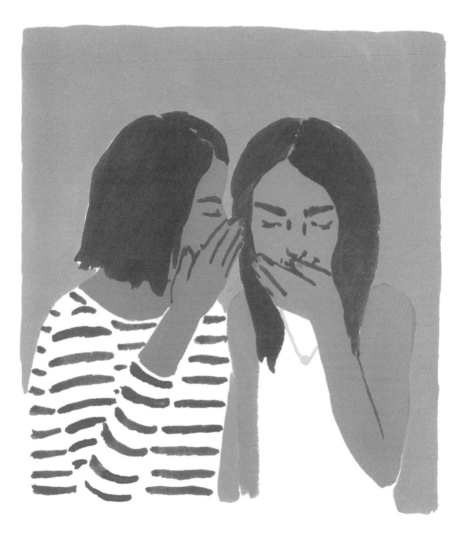

HANDSHAKES

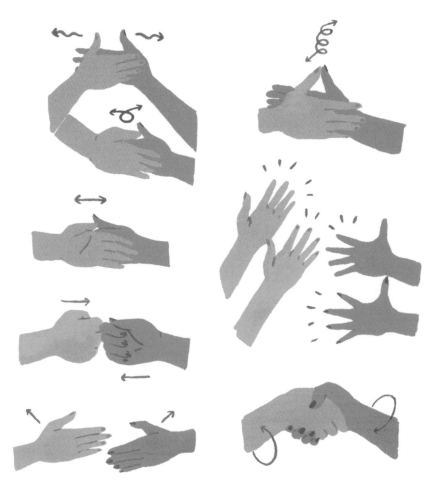

Our extremely intricate handshake usually takes ten minutes to remember, and five minutes to execute. We haven't done it in years — but that DOESN'T MEAN WE COULDN'T IF WE REALLY WANTED TO.

BFF VOCABULARY

"Do you need a freshie?"

I'm going to the bar — I'll grab you a fresh drink.

"It's going to be supes fun."

Short for super. This phrase began ironically (because it sounds so dumb), but now we say it and mean it.

"He's a normal."

Someone who is just a regular person instead of a unique special flower (like you and me). Someone who doesn't "get it."

"Come here, you'll fit in the inbetweenus."

The space in between us, like when we're sitting on a couch or lying in bed. Almost always perfect for a cat.

"She's a real Wednesday."

Someone who wiggles their way into a friendship to advance their own social or professional agenda. Named for the day of the week we had softball practice in fifth grade with a real Wednesday.

DAYDREAMS

Names for our band (despite the fact
that neither of us plays any instruments)

Best Friend
Social Club

Bad Kittens

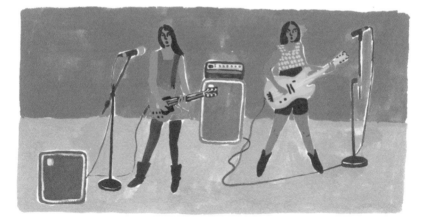

The Popsicle Twins

Frankie and
the Heartbreakers

The Eyebrow Sisters

BFF tattoos (that we may never ever be able to decide on)

XO

Pets and Their Names

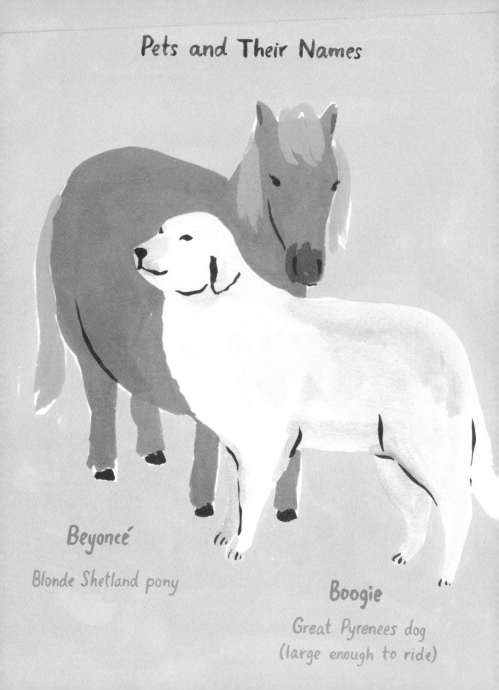

Beyoncé

Blonde Shetland pony

Boogie

Great Pyrenees dog
(large enough to ride)

Momo

Jojo

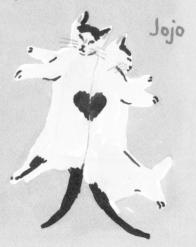

Kittens that make a heart
when they lie together

Pancho

Tropical puffer fish

Jerry

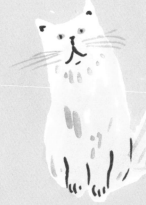

Lizard who goes
everywhere with us

Cream Puff

Persian cat

Outfits

'70s babe

Baywatch
(but at the public pool)

Tough girl
(wish I could pull
off this jacket)

GLITTER
(only worthy of New Year's
Eve or a Madonna concert)

Things We Just Really Want to Try

Candle making

Pickling

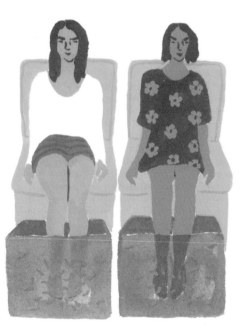

Pink hair

Fish pedicure

Scuba diving

UNSPOKEN RULES

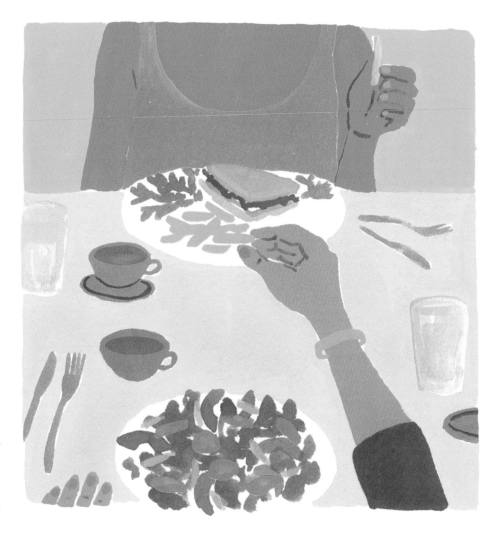

You get to eat half of the food I order,
and I can eat half of yours — without asking.

If you don't like how you look in a photo, I will never ever show anyone. (But I can keep it forever if I look really good in it.)

We can't date someone the other disapproves of.

The spitter
(words and food)

Fish lips

Mr. Hoop Earring

The man bun one

Plaid shirt guy

Wrinkles

Sergent BO

Dude who makes experimental noise rock, or totally would if he didn't have a job he despises but never stops talking about

We always tell the truth.

OREO PIZZA IS NOT A THING

I can borrow any of your clothes,
and you can borrow any of mine.

(PS: That stain was already there)

A NIGHT ON THE TOWN

Our cabdriver singing
us show tunes

Singing show tunes
to our cabdriver

Stumbling into a fancy private party and
getting free hordivores. hordvors? hordsvours?
We are not fancy.

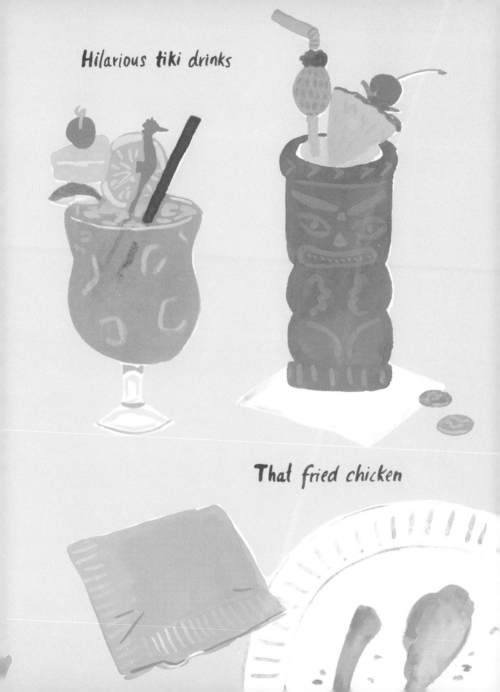

Hilarious tiki drinks

That fried chicken

Sneaking into
the cemetery

Photo booth pictures with a
Swedish man named Bjarni

Learning salsa from
two girls in a park

Eating pizza on the
steps of an old church

The midcentury-ish chair you found on
the sidewalk and insisted on taking home

The place that has
free cheese puffs

Staying out just a little
longer (please)

BUT SOMETIMES,
A NIGHT IN > A NIGHT OUT

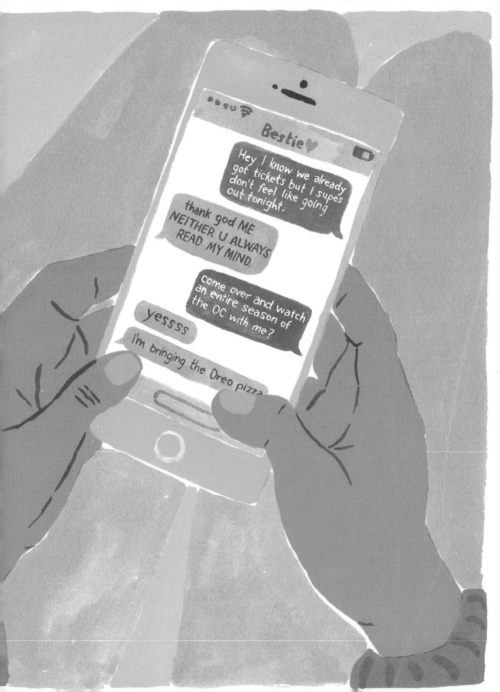

SUPPLIES

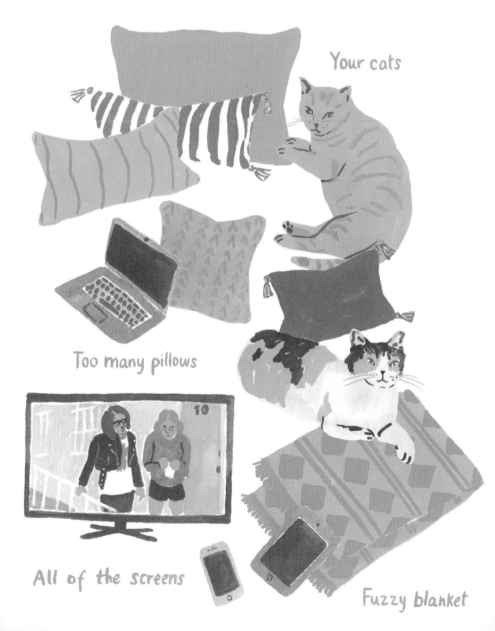

Your cats

Too many pillows

All of the screens

Fuzzy blanket

THE GARB

Hoodie and sweats

Sheepskin boots

(No photos
tonight, please)

SNACKS

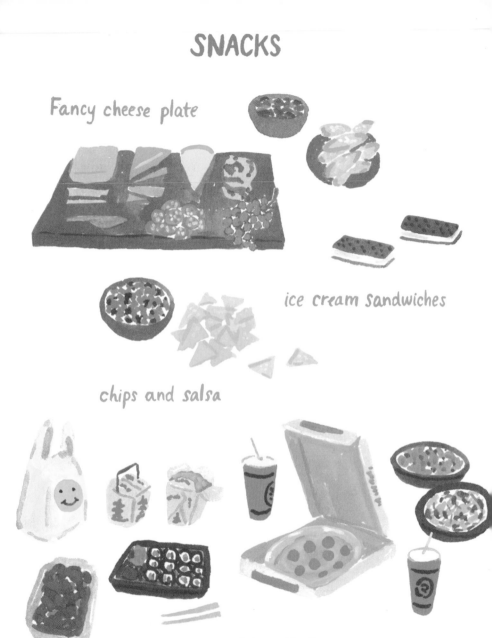

Fancy cheese plate

ice cream sandwiches

chips and salsa

ALL OF THE TAKEOUT

DRINKS

SHIRLEY TEMPLE

Add a splash of grenadine to a glass of ginger ale. Optional — throw in a shot of vodka!

ORANGE SHERBET FLOAT

- ½ cup **orange** juice
- ½ cup seltzer
- ½ **cup orange** sherbet

Pour **orange** juice and seltzer into a tall glass. Add sherbet and let it fizz!

THERE IS SO MUCH WE DON'T KNOW

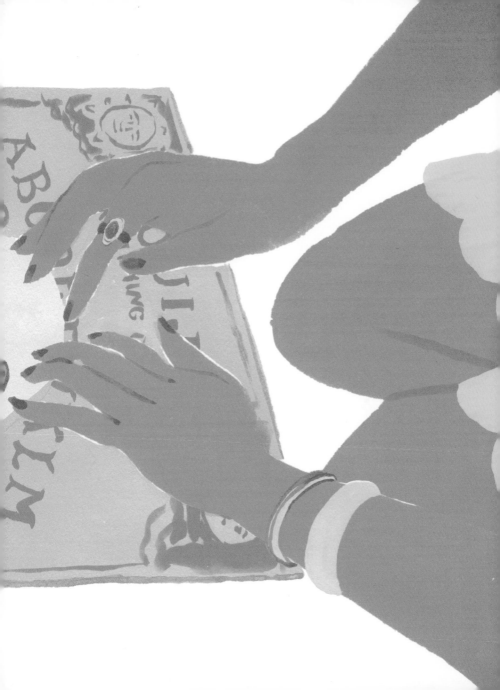

BUT IT HELPS THAT
WE KNOW EACH OTHER

"Oh yeah...yeah...

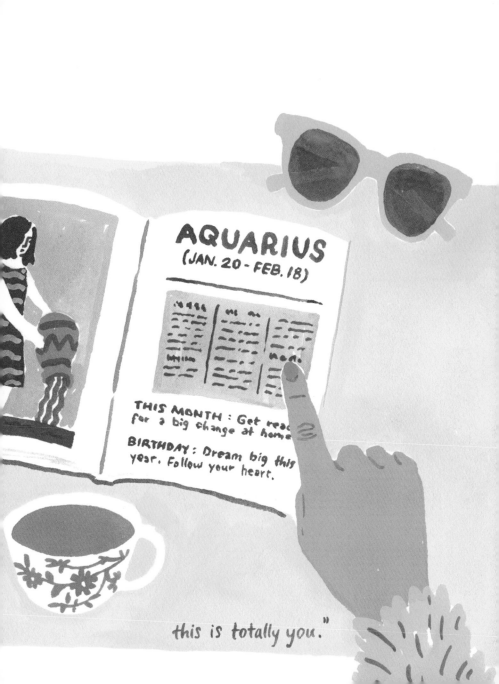

AQUARIUS
(JAN. 20 – FEB. 18)

THIS MONTH: Get read for a big change at home

BIRTHDAY: Dream big this year. Follow your heart.

this is totally you."

Literally us.

YOU ARE SO WISE

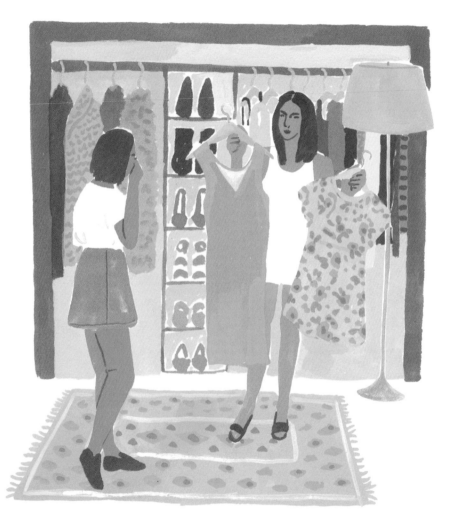

I can always count on you to help me make important life decisions.

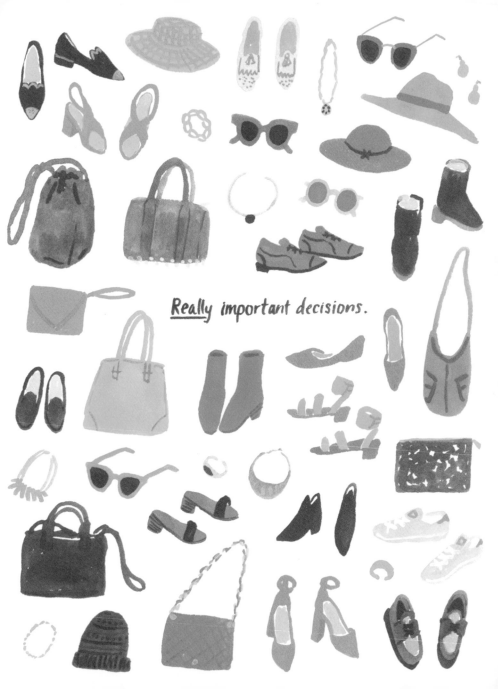

Really important decisions.

Like how-am-I-supposed-to-know-what-represents-my-true-self? decisions.

High ponytail

Bun

Fancy updo

Cat ears

Bow

Cornrows

Sunburst

Cloud

Braid

French braid

Fishtail braid

Milkmaid braids

Double buns

Donut

Beehive

Fire hydrant

Postmodern

Someday, when we're both famous, we'll write each other's biographies.

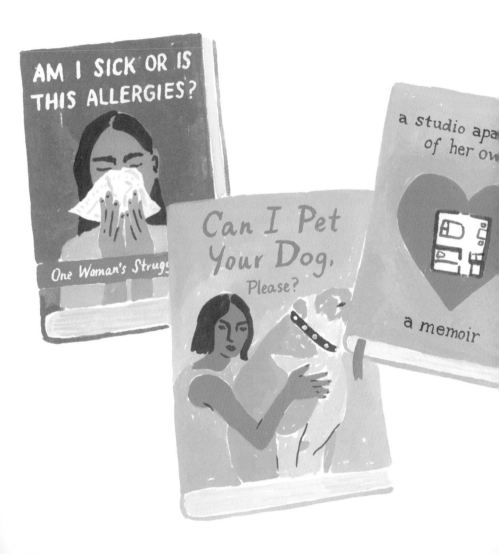

AM I SICK OR IS THIS ALLERGIES?

One Woman's Struggle

Can I Pet Your Dog, Please?

a studio apartment of her own

a memoir

Do I Need to Wash My Hair Today?

a Story of Resiliance

Is It Iced Coffee Weather?

A Woman's Quest for the Truth

YOGURT
FOR EVERY MEAL

THE TRUE STORY

She Never Studied Abroad

A Memoir

I know about your first boyfriends

Little Petey
6th grade

Kyle the Skater
8th grade

Punk Rock Jason
11th grade

and girlfriends

your punk
phase

your short-lived nose ring

↖ you haha

the sorority you
joined in college

you're the only person who was there for my goth phase

AND my vegan phase

and the summer I had one dreadlock — at first by accident and then on purpose

oh, and the time I got poison oak on my butt.

Come to think of it, maybe we will respectfully omit some of these things from our biographies.

SOME THINGS HAVE CHANGED

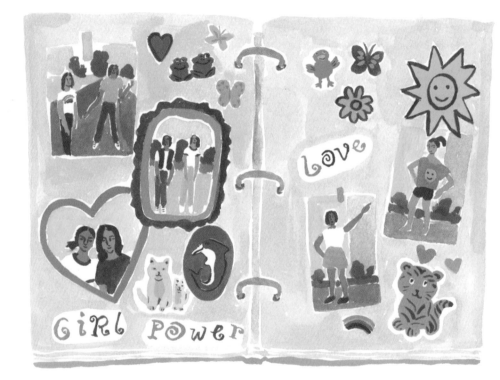

Photo album

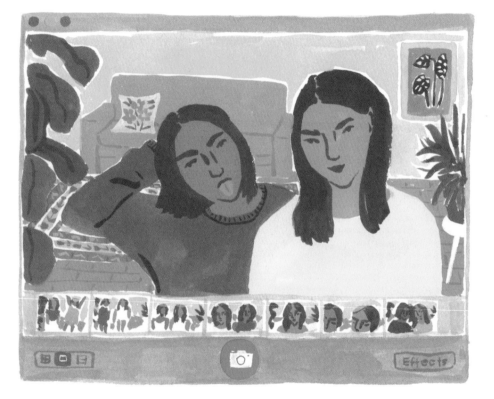

Photo booth

We used to play MASH in middle school.

M.A.S.H.

Boy	Wedding dress
~~Dylan~~	~~white~~
~~Max~~	~~black~~
(Ryan)	(baby pink)
~~Shia LaBeouf~~	~~red~~

Car	Honeymoon
~~pink limo~~	~~Hawaii~~
~~sailboat~~	~~Palm Springs~~
(Jeep)	~~Tokyo~~
~~Volvo wagon~~	(Disneyland)

Kids	Career
①	~~zookeeper~~
~~2~~	~~journalist~~
~~+2~~	~~painter~~
~~just cats!~~	(scientist)

⑤

Now we spend Sunday flipping through these pages.

You were convinced you could
make me levitate at sleepovers.

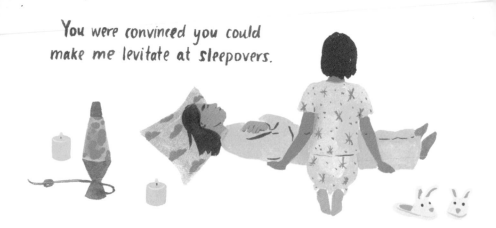

Now we take aerial yoga together.

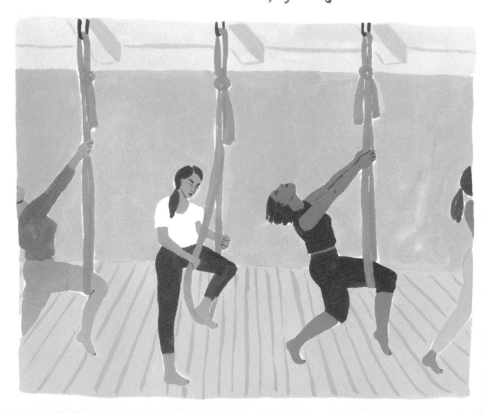

One summer we built a fort in your backyard.

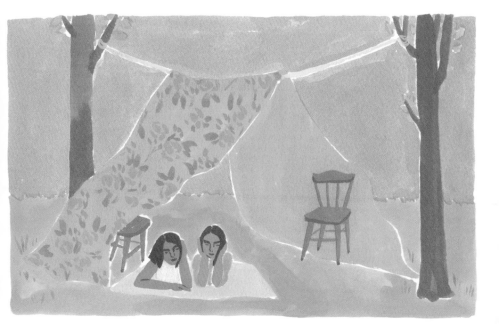

Then we camped in Yosemite.

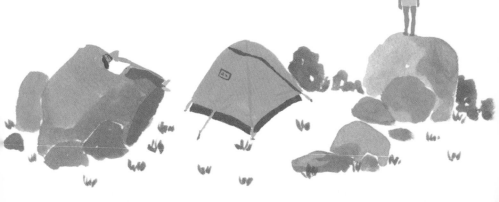

The unavoidable hours of homework every weekday...

which are now unavoidable hours of
real work, sometimes even on weekends.

We spent our allowance on tube tops at the mall.

Now we spend our
paychecks on $12 juices.

HALLOWEEN
We are costume geniuses.

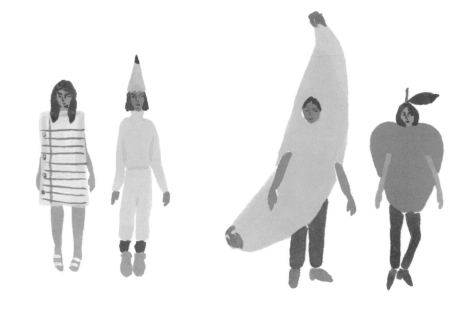

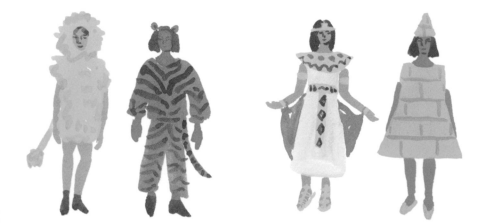

VALENTINE'S DAY

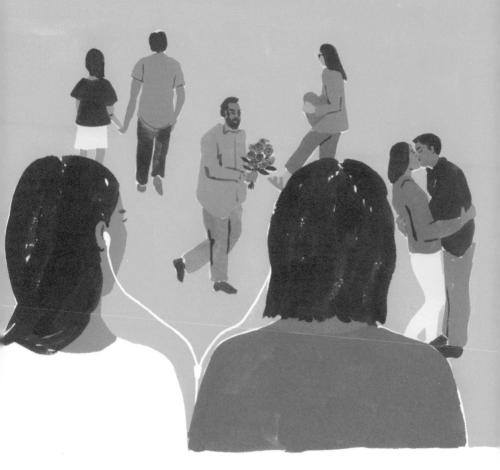

We've always known it's really about
the best friend kind of love.

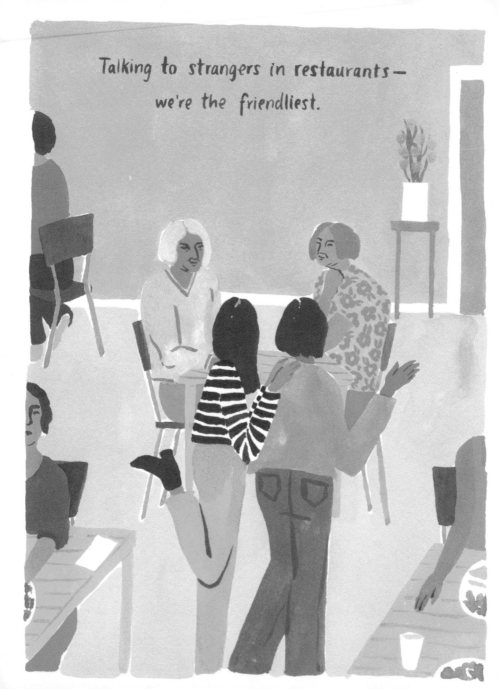

Talking to strangers in restaurants —
we're the friendliest.

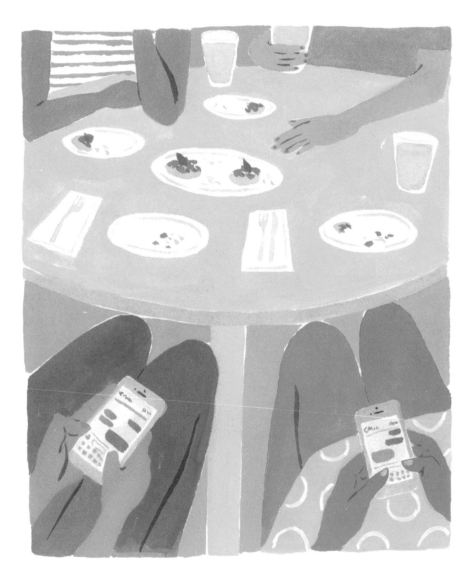

Passing notes (or texts) about people.

Marathon phone conversations.

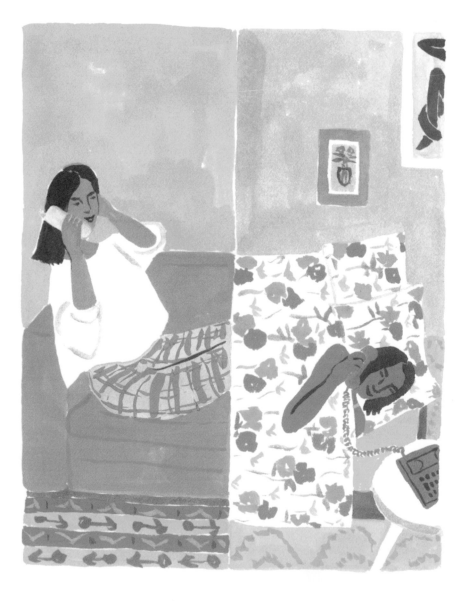

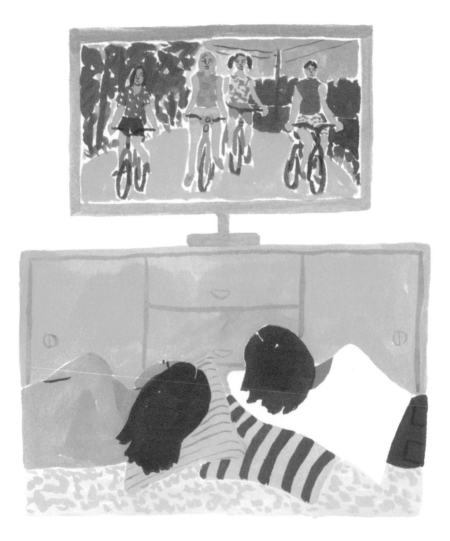

Falling asleep on the couch
watching our favorite movie.

I've kept every single birthday card

to My Bestie ♡

H♡PPY BIRTHDAY DARLING

HAPPY BIRTHDAY BB!

Happy I love y

Happy Birthday

and every single photo

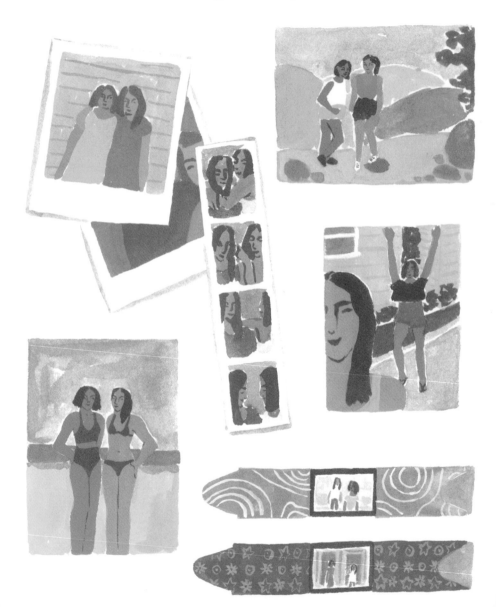

and every single thing that's ever meant anything, really.

Ticket stubs from concerts

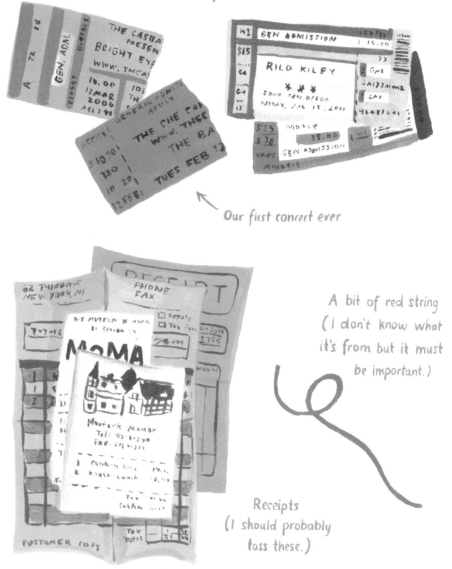

← Our first concert ever

A bit of red string
(I don't know what
it's from but it must
be important.)

Receipts
(I should probably
toss these.)

Letters you wrote me every day when I went to camp.

Dear

I miss
s...
P...
really
th...
Please
ca...
sure!
wa...
Write
Lov
ok!
xo
♡ so soc

don't be homesick. home is boring without you. nothing is happening here. have fun. for heaven's sake, KISS SOME BOYS.

Bits of nature I've collected from trips we've been on

Sticks from
Fort Tilden

Shells from Miami Beach

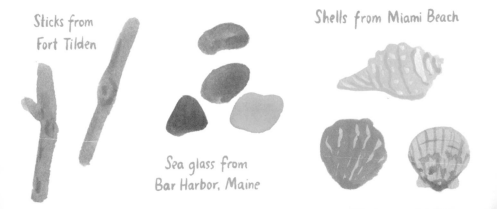

Sea glass from
Bar Harbor, Maine

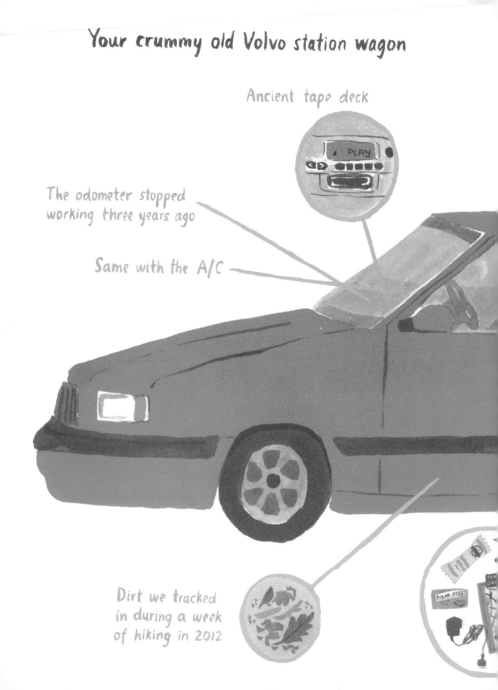

Your crummy old Volvo station wagon

Ancient tape deck

The odometer stopped working three years ago

Same with the A/C

Dirt we tracked in during a week of hiking in 2012

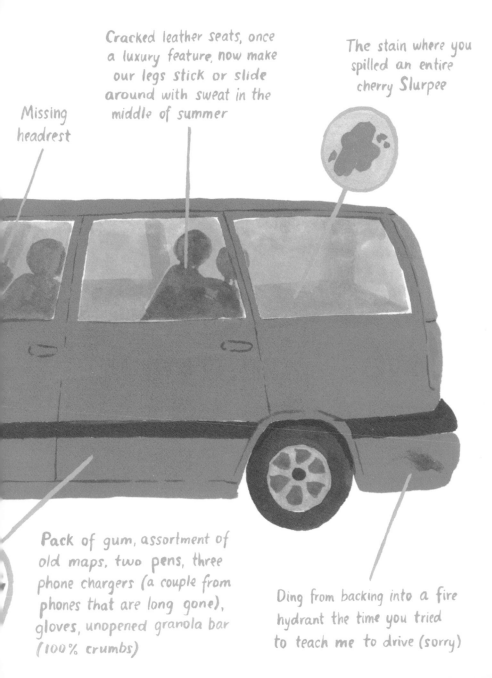

Cracked leather seats, once a luxury feature, now make our legs stick or slide around with sweat in the middle of summer

The stain where you spilled an entire cherry Slurpee

Missing headrest

Pack of gum, assortment of old maps, two pens, three phone chargers (a couple from phones that are long gone), gloves, unopened granola bar (100% crumbs)

Ding from backing into a fire hydrant the time you tried to teach me to drive (sorry)

It is the most perfect car in the world.

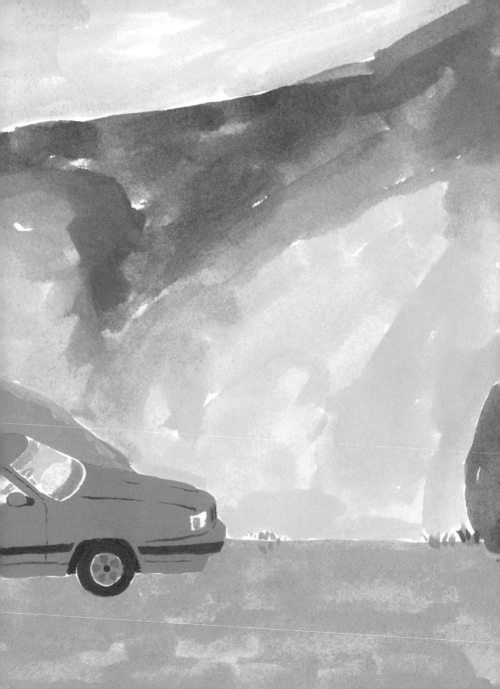

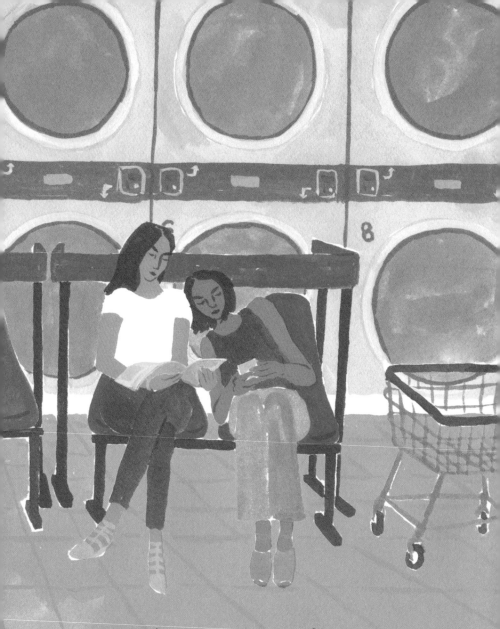

when it doesn't matter at all.

And when it really, really does.

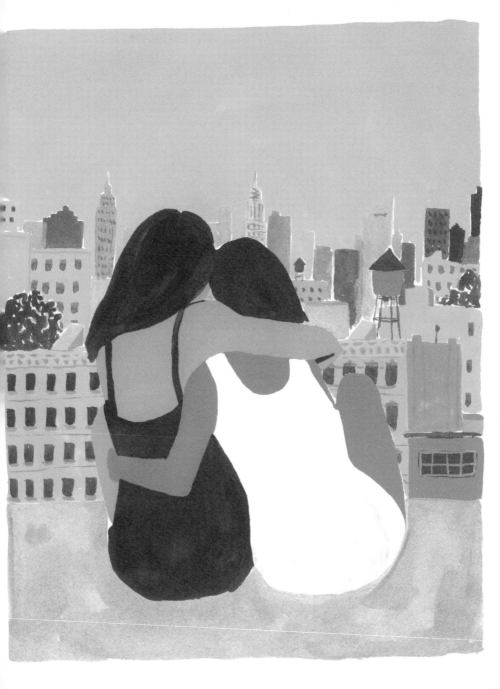

When I was at my lowest, you came over with flowers, dried my tears, and forced me to shower and change the sheets.

You dragged me out of the house so I could see that the world was still there.

There were still flowers, sun, and trees, coffee, movies to see, and dogs to pet.

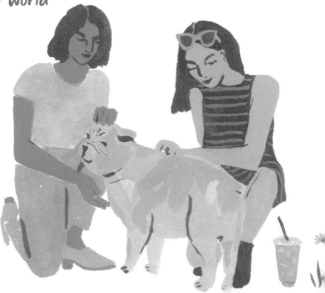

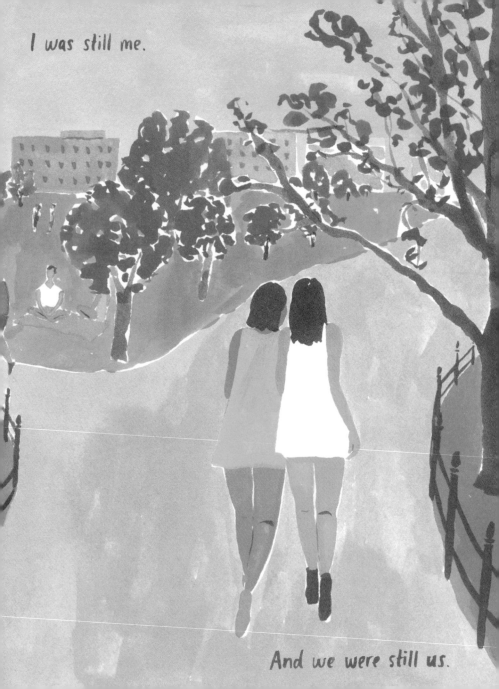

I was still me.

And we were still us.

EVEN WHEN WE'RE LOST, WE STILL HAVE EACH OTHER.

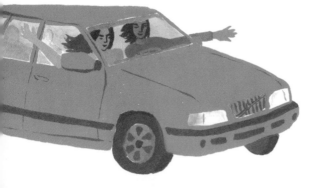